ON THE
·S·P·O·T·
GUIDES

STUDIO
TIPS & TRICKS

GEOFF STEAR & JUDY MARTIN

·OUTLINE PRESS·

AN OUTLINE PRESS BOOK

© OUTLINE PRESS (BOOK PUBLISHERS) LIMITED 1989
First published in Great Britain in 1989 by
Outline Press Limited, 115J Cleveland Street
London W1P 5PN.

ISBN 1.871547.01.6

This book was designed and produced by
THE OUTLINE PRESS LIMITED.

Typesetting by Midford Typesetting Ltd.

Printed and bound by Grafoimpex, Zagreb, Yugoslavia.

·C·O·N·T·E·N·T·S·

chapter one

INTRODUCTION

Good studio management
is as important as your
design skills. Set up a
smooth operating
procedure that carries
you through from first
commission to final
payment.

The graphic artist of today, whether employed in a top commercial studio or working freelance, must have a wide range of abilities and be highly skilled in numerous practices related to art and design, both on the creative side and in the technical processes of producing artwork for print. Many skills have been learnt and developed over the years through the experience of designers and artists. New techniques, materials and equipment have introduced practical adaptations of these working methods, often saving time, improving quality and creating new visual effects.

This 'On the Spot Guide ' explains all you need to know about studio practices, old and new. It contains a wide range of information which can save you time and money, and improve your graphic skills and presentation. The experience of working designers is assembled in a simple format with clear, explanatory text and illustrations.

The book is divided into sections based on the way a project progresses through different stages in the studio. In the following chapters, you will find guidance on quick, easy and professional ways to produce visuals, layouts, finished artwork and presentation material, including alternative methods for tackling particular jobs. At the end of the book there is a comprehensive glossary that demystifies the 'jargon ' of the design studio, together with some useful reference information.

But to start with, this introduction deals with the basic guidelines for handling a commission from beginning to completion, with advice on businesslike studio management, both in your dealings with clients and in keeping your own affairs in order. These are essentials of studio practice that can make your day to day business run smoothly, easily overlooked when you have urgent deadlines to meet, but likely to save much time and trouble in the long term.

Carrying out a commission

The brief This initial stage of the artist 's work is most important, yet easy to mishandle. If you get the brief wrong, then the whole job goes amiss from the word go. In an ideal situation, your client would supply you with a written brief. Unfortunately, this rarely happens, so keep the following points in mind when you attend a briefing:

☐ Listen very carefully, ask questions about anything that is not clear, and make notes or rough sketches that will remind you of the details discussed.

☐ Pick up samples of previous work they have used, especially if they have 'house styles ' for typefaces, preference for illustration or photography, colour schemes etc.

☐ Some clients know precisely what they want and will require you merely to execute it. Others may have little or no preconception and will give you an open brief. Make sure you understand which situation you are dealing with and who you are answerable to. Don 't take a brief from a junior if you will be making your presentation to the boss.

☐ Don 't leave room for ambiguity over costs and delivery times - is there a budget you must work to or do they want you to give estimates or quotes? Is it an overnight job or a few weeks to deliver? Find out now, not when you have spent a lot of time on a job that turns out to have a very small budget.

Visuals The first stage of the job will probably be to supply rough scamps or sketches to show your initial concepts or ideas on the way you intend to tackle the job. These you show to the client to obtain his or her approval that you are heading in the right direction. You may be asked to try again in a slightly different way before proceeding to the next stage.

If the initial brief was tight you may have missed out on the scamps and proceeded straight to the visuals. Again, you should check with the client what he or she expects, or wants to pay for. Visuals can be produced with varying degrees of finish - either 'knocked in ' pretty quickly and freely, or very highly finished and mounted for presentation purposes. You may be required to produce actual mock ups, either two- or three-dimensional.

Layouts Once the visuals have been approved, possibly with a few amendments, you can proceed to working layouts and/or typographic traces. These are usually just pencil traces but very accurate, working out column widths, headlines, photo and illustration sizes, positions and crops, type mark-ups or guides for the typesetters to work from. Again, these should be approved by the client before typesetting is ordered and you proceed to artwork.

Artwork You can now produce camera-ready artwork, prepared on line board and complete with keylines, rules, text and headline setting in position, trim and fold marks and guide prints or blue-line traces as positional guides for the photographs and/ or illustrations. This 'mechanical ' process is the final stage before print and must be very accurate, precise and clean. Some studios prefer to make up artwork on film, then take final line prints for approval, yet line board mechanical artwork is still the preferred method and the most common. Finally, you cover the artwork and mark the overlay with printing instructions.

On completion the artwork is again presented to the client for approval. This is the most essential check your client makes. Make sure he or she thoroughly scrutinizes every detail and if possible signs the back of the artwork after any necessary amendments have been made. The next step is for the job to be printed and if any mistakes escape detection and are printed in that incorrect form, they could prove very expensive indeed, possibly costing thousands. If the client has signed approval it is the client 's responsibility, not yours.

Print You can now hand over to the printer, and in most cases your client will probably handle the job from now on. If you are handling the the print stage also then you should supervise it through at all

stages, checking colour proofs and correcting as necessary. This is a specialist job, especially in colour printing, so don't take on this stage unless you are fully confident of your ability.

Studio management
Written brief If possible, obtain a written brief from your client. Then there can be no dispute over whether you have met their requirements. Clients do have a habit of changing their minds after you have done the work.

Estimate/quote You should supply your client with a written estimate or quotation defining exactly what you will be doing, and including a breakdown of costs. This must be quite precise, especially over any items you will not be supplying, but expecting your client to supply, such as copy or photography. If you don't specify responsibility for costs in your quotation, you could end up arguing about who should pay suppliers' bills.

An estimate is what it says and that only, an estimate of what you think the job will cost, whereas a quotation is fixed; that is, you must stick to that price whatever once agreed. This is a very important difference you must be aware of.

It is not always possible to know in advance how long a job will take or exactly what will be required as it progresses, in which case you cannot quote for the job but should tell your client what your hourly/daily rate is and then keep the client informed of the time spent, plus outside costs/materials etc.

Purchase order The golden rule, never start work without a written, official purchase order, with your client's job/order number. This commissions you to do the job and should litigation ever become necessary to obtain payment, this order is virtually essential. If you have previously submitted a quotation, the order should have the agreed sum on it. Make sure it is signed by someone authorized to do so.

Job book and number system As soon as you accept a job you should enter details of it into a job book and raise an official job number. This number stays with the job throughout its progress through the studio at all stages and appears on any purchase orders you may issue, to typesetters, for example,

This enables all costings to be related back to the correct job quickly and simply.

Your job book should be divided into columns across a double page spread to show essential information, i.e. date job raised, job no: client's order no.; client's job no.; client's name; brief job description; name of person ordering job. This is a basic list: you may find your specific needs require different information.

Job/time sheet Now you should have a job sheet, again having the job number and basic details entered on it. This is essential for either the freelance graphic artist or a full studio set-up. Every detail of the job as it progresses through its various stages goes onto this sheet. And this forms an essential record for your keeping track of costs and time spent. You should work out a design to suit your individual requirements; for instance, if most of your work is artwork, you may require more space for your time (a line for each day) and a special box for recording different types of PMTs done with space to add to as you do them, day by day.

Invoice As soon as possible after the job is completed, invoice your client. Remember the quicker you invoice them, the sooner you will be paid. Don't wait for your outside suppliers to invoice you, that could be some considerable time, telephone them and ask for a costing, then you can invoice out even before you have had your bills in. Be sure to account for all your outgoings though, check your job sheet and make sure everything is covered, from that odd sheet of lettering to motorcycle couriers and the big bills such as typesetting and printing.

Your invoice should be detailed, breaking down the costs; time spent on that at this stage saves you repeating the whole exercise when the client returns your invoice for explanations of 'high charges'. Of course, if the job was 'quoted' your invoice should read as the quote, with possible additions where client amendments or additions were requested.

Statements Unfortunately you will find that however efficient and speedy you are in invoicing not many clients pay so eagerly. Send statements regularly with polite but firm reminders of your terms of payment (usually 30 days). Very few clients pay up without being reminded and efficient statements are better than angry phone calls.

VISUALS AND ROUGHS

Whether your client requires rough scamps or highly finished visuals, a professional approach to the job helps to create the right impression.

Safe storage for markers

Markers tend to start drying out even when kept firmly capped. You will find that it helps to prolong their life if you store them in plastic food containers with airtight lids.

Charting your colours

Each time you buy a new marker pen, add a sample of the colour to the paper or artboard surfaces you regularly use. Mark each sample with the name or reference number of the colour. In this way you build up a useful colour chart of the different shades. The colour guide on the cap or barrel of the marker does not always show the true effect, and different surfaces can have a distinctive influence on the colour quality, depending on the tint or absorbency of the paper product.

You can include samples of mixed colours, one laid over another, or tonal gradations, such as the range of greys overlaid to darken by degrees.

When you need to apply colour to your visual, you have at hand a quick reference for the actual colour or shade you require - no risk of finding too late that you have applied the wrong colour and ruined a good visual.

❝Keep a chart to show the actual colours of your markers on the paper you normally use for colour visuals❞

Applying flat colour

If you have to apply a large area of one colour using
a marker, it can be difficult to eliminate the marks
made by the marker nib. But you can more easily
wash on the colour using the ink reservoir pad from
inside the marker.

1. Using a sharp knife, cut through the barrel of the
marker at the nib end.
2. Use tweezers to pull out the inky pad from inside
the marker.
3. To keep your hands clean, use a bulldog clip to
hold the pad and apply the colour by rubbing the
pad across the surface.

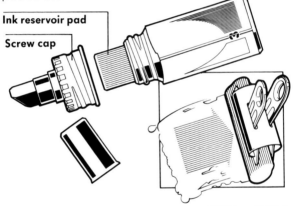

Ink reservoir pad

Screw cap

**❝Lay a broad area of colour using the ink
reservoir pad from inside the marker❞**

Tinting with markers

To get an effect similar to a percentage tint of a
colour, touch your marker nib on a solvent-soaked
pad before applying it to your visual. This lightens
the colour effect and makes a better match than
selecting a separate, paler marker colour.

Vignetting with markers

To make a colour area with gradated tones, first rub
the paper or board surface with lighter fuel or marker
solvent and apply the marker colour into the damp
patch, allowing the edges to spread and fade.
In smaller and more precise areas, spread
the colour into the solvent with a cotton bud.

The first stage in vignetting with markers is to douse the paper with lighter fuel, flat tones of marker colour can be laid on holding the felt in a paper clip.
In some cases as many as four shades of one colour are used to form a single vignette.

Shaping up

Try cutting your marker nib with a sharp scalpel to shape it for special effects, such as ripples in water.
You can also trim the nib to match an exact weight of line for underlining main headings in a set of visuals.

Broken colour effects

New felt-tip pens give a very solid inked line, when sometimes you require a lighter or slightly 'broken' effect. So hold onto old felt-tips instead of throwing them away when they are past their best. Keep them separate from the new stock, stored in a marked jar or an old mug for easy recognition.

❝Make use of worn felt-tip pens for broken-line effects in your visuals❞

Revitalizing markers

Marker manufacturers supply solvents which can be used to revive tired markers and improve the colour quality. This way you get more milage from your markers, but keep these for roughs rather than finished visuals or artwork as the colour may be a little uneven.

Clean colour

When using markers with a plastic ruler, French curve or template, turn the ruler or guide over if it has a bevelled edge, to prevent an unsightly bleed of colour spreading under the edge.

If the edge is not bevelled, a layer of masking tape applied to the underside raises it enough to stop an ink bleed.

An alternative way of using a ruler cleanly and effectively with a marker is to tilt up the ruler, resting it firmly on the lower edge, and guide the marker at right angles to it along the upper edge.

Protect your templates

Plastic guides and templates can suffer damage or distortion from the effect of solvents in certain types of marker colour. Prevent this by applying a strip of masking tape to the edge of the guide before using it with a marker. If you apply a new piece of tape for each marker colour, you also avoid the possibility of the marker nib picking up another colour left on the plastic edge from a previous application.

Painting with marker colour

The ink contained in markers is either water-soluble or waterproof. If you want to spread marker colour to create washes and blends, you can work into water-soluble colour with a wetted brush or cotton.swab: for waterproof ink, use a spirit-based solvent. The tool or material you use to apply the solvent has an effect on the visual quality of the colour area, so you can experiment with cotton balls, soft tissues, or rags as well as artists ' brushes.

Colour backgrounds for marker work

An atmospheric or smoothly gradated background tone can be applied to a whole sheet of paper by scraping dust from a pastel stick and spreading it with a rag or cotton ball. This gives a characteristically soft colour effect.

Air markers are an alternative way of covering a background quickly with colour. You can obtain an accessory that converts a marker into an 'airbrush '.

Colour copying

Some photocopiers have separate colour cartidges so you can copy headings, type etc. for your visual in individual colours and paste them up together. If you tape registration lines on the copier screen, you can also produce a four-colour visual by changing the original and colour cartridge at each stage.

Watercolour effect visuals

If your visual requires illustrations that include watercolour wash effects, light and free, it is a good idea to do these illustration visuals separately on tracing paper rather than on your layout. The tracing paper, being much less absorbent, allows ink or paint to wash on freely and appears much paler. When fully dry, cut out the image area and paste it to the main layout.

Instant masking

The adhesive-edged sheets from a message pad can be used to create instant masks for straight line effects in colour visuals.

Scaling your roughs

Slip a sheet of graph paper under your layout paper when sketching out roughs. This gives a good guideline for the relative scale and proportion of different elements in the design.

❝Work with graph paper under your layout paper to give guidelines for your design roughs❞

Trying out colour roughs

If you have a sketch rough that satisfies you or the client, but have not yet made firm decisions on the colour elements in the design, take a number of photocopies of the original rough and colour them up quickly using markers or watercolours, trying out different colour combinations.

If the original has heavy tonal variations,

adjust the photocopier to make the print lighter, so the colour is easily visible when applied on top of the monochrome image.

"Use photocopies as a base for trying out different colour treatments in your design"

Flat-colour visuals
This is a simple method for producing a clean colour effect in mock-up visuals that require flat colour areas, such as book jackets or packaging. Make a simple artwork in keyline only: you can draw this twice-up, tracing off headings etc. Then take a film PMT of the artwork to the correct size and colour up to the keylines on the reverse side of the film, using gouache. From the right side the colour is bright and flat, with no brushmarks showing, and the black lines stay sharp and unbroken by the paint; the film gives a smart, glossy finish to the design. The whole cel can finally be superimposed over a separate background illustration if required.

Colour matching
When you need to match tint areas or coloured papers, cut two windows in white paper and put them over the colour samples. Isolating them from other colour influences helps you to make an accurate match.

Two-stage illustrated visuals
When you have a number of illustrations or visualized photographs to add to your presentation roughs, such as for a brochure, this method produces a clean finish.
1. Draw up headings, rules etc on your main layout, with box rules for all your squared-up pictures.
2. On a separate sheet, pencil in the boxes for the illustrations and colour them up in place. When applying marker or watercolour, you don 't have to worry about the colour bleeding over the edges of the boxes, especially useful with wash backgrounds.

3. Carefully trim the illustrations just inside the pencil lines and paste them onto your main layout. The result is a clean, sharp mock-up, a much more finished look without any bleed on the illustrations.

❝For a clean finish, work the illustrations for your visual separately, trim their edges and paste them to your main layout❞

Combining illustration styles

Certain jobs require you to combine a large freestyle background with a tighter image in the foreground, perhaps a product in a given setting, or a car seen against a landscape background. In this case, it again makes sense to draw the images separately.
1 Make up the background image with free atmospheric washes, applied with speed.
2 Treat the foreground or main subject separately with much more detail, using fine lines and tight marker control.
3 Trim the main illustration carefully and superimpose it on the background. You can add the final detail at this stage, such as cast shadows or highlights. Your illustration has a smart finish and a greater feeling of depth.

Pre-releasing dry-transfer letters

It can be difficult to apply dry-transfer lettering when the surface is delicate or uneven. Pre-releasing the letters enables you to lay them more easily, without making indentations in the surface.
1. Hold up the lettering sheet and rub the required letter with a soft pencil on the front of the sheet. When the letter appears paler in colour all over, it is released from the backing sheet
2. Place the sheet on the surface and apply slight pressure to the letter.
3. To secure the letter in place, cover it with the backing sheet or a piece of tracing paper and burnish it, using minimal pressure.

Reversed-out white lettering

The simple way to create reversed-out white lettering on a coloured background is to use dry-transfer lettering in white, but if this is not available in the required typeface, you can obtain the same effect by

this method of applying and lifting black lettering.
1. Lay down the characters and burnish them in place in the usual way.
2. Apply the background colour over the lettering. The best method is to use a water-based paint applied with a pad of cotton wool, which lays a continuous tone free of brushmarks. Spirit-based paint or ink dissolves dry-transfer lettering and cannot be used for this technique.
3. Allow the colour to dry completely, if necessary using a hairdryer to speed up the process.
4. When the paint is dry, use masking tape to pick up the letters one by one. A low-tack adhesive tape lifts the letters without damage to the underlying surface.
5. If any marks or ragged outlines remain within the letterforms, scratch them away using a scalpel blade.

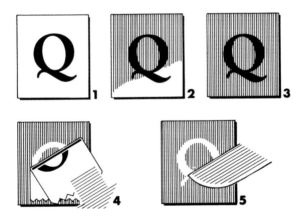

White on black
When applying white dry-transfer lettering to a black ground, a useful tip is to lay a strip of low-tack art or masking tape across your layout as a base rule. You will find this much easier to work to than a pencil line on the black background. With white or coloured lettering, you will probably find it necessary to apply a second layer to obtain a good opaque finish.

Remember that you can use a PMT machine
to produce a reversed image of a black-on-white original.

Instant lettering any colour you need

When you need coloured lettering for presentation roughs, and rubdowns or 'special' dry-transfer sheets are either too slow or too expensive, a quick and easy method for producing simple headings or titles is to use an instant lettering positioning system, with air markers to provide the colour.

1. Rub down your copy onto the paper transfer strip, using white instant lettering.

2. Spray the lettering with the colour you require using an air marker to obtain even, flat colour. You can mix colours if you wish.

3. When you are sure it is dry, place the strip onto the transparent transfer sheet and moisten with the pad supplied.

4. Remove the paper sheet, leaving the letters transferred in reverse on the plastic strip.

5. Put the plastic lettering strip in position on the artwork.

6. Rub down the lettering by the usual method for dry transfer, remove the transparent strip and burnish the lettering in place.

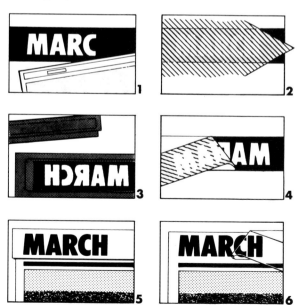

Correcting a finished visual

If you discover a spelling mistake in a near-finished or completed visual, you don't have to do the whole page again.

1. On a clean sheet of layout paper, redraw the corrected version of the line (or word) containing the error.

2. Place the corrected line over the layout, aligned to the incorrect original. Secure it with low-tack tape. Using a sharp scalpel, cut through two layers to trim out the corrected line and the line on the original layout, but without cutting the base paper on which the layout is assembled.

3. Lift the correction strip and remove the original line from the layout.

4. Clean off the base layer with an appropriate solvent to remove traces of dried adhesive.

5. Apply fresh adhesive to the corrected line and put it down in the open space on the layout. As it was cut together with the original line, it should precisely fit the space left after removing the original. Make sure the alignment is correct and the new piece is firmly adhered to the layout.

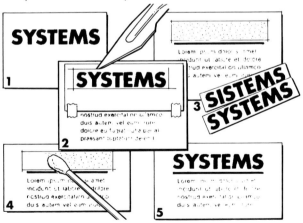

Type visuals

Some photocopiers can enlarge or reduce an image in one dimension only. If your equipment has this facility, it is a quick and easy way to produce an effect of expanded or condensed type.

An alternative to rubdowns
Rubdowns are dry-transfer designs made from your own artwork, often used for detailed presentation visuals but an expensive option.

Laser prints or colour photocopies can be a very useful and much cheaper alternative to rubdowns. For instance, if you are preparing a whole campaign of ads, brochures and posters, using a coloured, perhaps quite complicated logo, you can draw up one or two at different sizes on an A4 or A3 sheet of layout paper, applying the colour with marker pens, then simply get a few colour copies at different sizes. All you need to do is carefully trim them out and stick them down on your presentation visuals.

"Use laser prints or colour photocopies as an inexpensive alternative to rubdowns"

Simulating type areas
When simulating columns of body copy on a visual by drawing double lines, in order to keep them regular without carefully pencil-marking all down the page, you will find it easier to lay a rule down the side of the column and place your set-square (triangle) against it, sliding it down and ruling at a constant measure.

An alternative method is to place your visual over the top of some printed material from, say, a magazine, with the correct type size, put them on the light box and rule over the underlying lines of type.

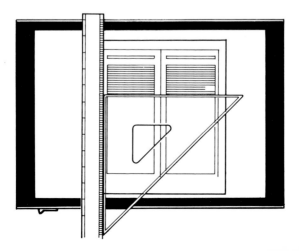

Laying in body copy

When applying body copy to presentation visuals, a good idea is to take a PMT negative from a sheet of Latin body copy and transfer it to adhesive-backed PMT film. The film is very thin and can be carefully trimmed to your column widths and laid down on your visual.

If your photocopier takes any kind of paper, you can feed either clear film or adhesive-backed PMT film through the machine, which is quicker and cheaper.

You may prefer with this method to go one better and copy existing setting from a previous artwork or from printed matter. In this way you can probably match the typeface, style and size.

ᴺTransfer body copy to clear PMT film for a sleek finish to your presentation visualsᴺ

Charts and tables

If your visual includes sets of tables and/or charts simulating numerous columns of figures, there is a simple method of creating the impression of this kind of layout.

1. Draw up the box indicating the whole area of the chart. Lay instant-lettering Latin body type over the boxed shape.

2. Trim to the inside type area.

3. Cut the block of type into columns and peel up the strips between the columns. You may then have to trim off individual characters to clean up the image.

Embossed lettering

This is a clever and simple way to reproduce an embossed effect for corporate-image presentation visuals

1. Draw the design for the letters accurately, then trace it onto thin cardboard so that the image appears the wrong way round.

2. Cut around the image accurately, and remove the resulting template from the surrounding cardboard.

3. Place a sheet of the required paper (or a very lightweight artboard) over the template and rub it gently with a burnisher until the image of the template is raised. You can probably use your thumbnail as a burnisher, if you are careful to work evenly and cleanly.

4. If the logo is for a brochure cover or business card, add the type areas and trim the paper to size.

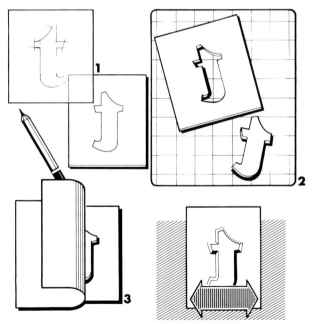

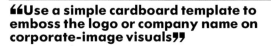

❝Use a simple cardboard template to emboss the logo or company name on corporate-image visuals❞

Assembling a brochure

You will find when making mock-up brochures that after mounting your visuals back to back, assembling and folding, the outside pages of the fold will be clean and sharp but the inside spreads sometimes bubble or buckle down the fold.

A simple trick to prevent this is to cut a fine strip out of the centre of the spread before the pages are assembled - approximately 1mm will do. But be careful to cut only through the layout and not the cartridge backing sheet. Then remove the strip and clean off any adhesive left before assembling. This allows the paper to fold without the unsightly bubbling.

❝Cut down the inner fold of mocked-up brochure pages to prevent the paper buckling along the fold❞

Securing a brochure

Another trick for assembling a brochure is accurate stapling. If your stapler is shorter than the page width and cannot be used in the normal way, open it out and use it open. But first place a soft eraser under each stapling position to receive the staple. Make sure you have the outside cover of the brochure uppermost.

When you have injected the staples, carefully turn the brochure over, remove the erasers and gently but firmly fold in the staple points. If you place a scalpel blade tip under the staple as you bend it over, this prevents the staples from closing too tightly. Tight staples may tear or pull the paper when you fold the brochure.

LAYOUT AND DESIGN

You have to know the
rules before you can
break them. Accurate
layouts are the framework
for creative versatility.

Working to a grid
The first step when designing the layout of leaflets, brochures, newsletters etc. is to set up a grid. This grid sets a plan on which you can lay out your type and image areas to a constant formula throughout all pages, thus giving a consistent feel to your layout. The grid defines the number of columns of type and thus the column width. All columns should be equal. First, decide how many columns you require, how wide you want margins, surround areas and gutters to be. Lay it out roughly, then when all your decisions on style have been made, you can work out the layout accurately.

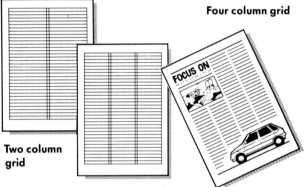

Four column grid

Two column grid

Three column grid

Once your grid is defined, remember it stays constant throughout all pages. However, all good rules are for breaking and this is no exception. Type and/or picture images can run across more than the single column; for example, in the four-column grid shown on this page, the main heading runs across two columns, as does the squared-up picture below, but the cutout image runs across all four columns with the text shaped around its outline. As long as the image of four columns is the dominant feel, that keeps the consistent impression throughout.

❝Establish a basic grid to give consistency to your page layout❞

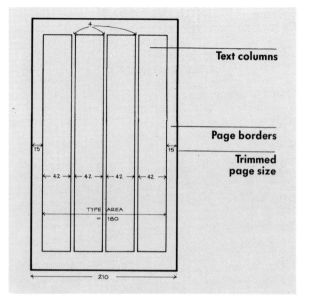

Text columns

Page borders

Trimmed page size

4

15 15

← 42 → ← 42 → ← 42 → ← 42 →

TYPE AREA
= 180

← 210 →

Simple mathematics

I find the pocket calculator an invaluable friend in the studio, being a quick way to deal with many straightforward but frequently necessary calculations such as working out column widths to construct a grid.

For example, working out a 4-column grid on a A4 page: your rough visual shows you have a margin of 15mm each side of the page; between these margins you want to fit four columns.

First work out type area width (all measurements in millimetres)

210 - 15 - 15 = 180

Then from that deduct 3 x column inner spaces

3 x 4 = 12

180 - 12 = 168

and divide by four

168 ÷ 4 = 42

❝Scribe a line across your set square to give a quick check on lines at right angles❞

Each column measures 42mm wide, allowing 4mm divisions between columns
Before proceeding to draw your grid, do a quick check to make sure you made no mistakes. Simply add across the page
15+42+4+42+4+42+4+42+15 = 210

Right angles

To save time when drawing up grids and layouts, scribe a line across your set square (triangle) at 90°to the long edge, leading up to the opposite corner. This gives you a quick check on lines at right angles to each other, and it's also useful for working up evenly cross-hatched shading.

Dividing any line into equal parts

This is an accurate method for dividing a line without having to measure on a ruler, which can cause inaccuracies if the total measurement is not easily divided arithmetically.
1. Draw a line leading at an angle from one end of the line to be divided. Use dividers or a compass to mark off the required number of equal sections at any suitable measurement.
2. Draw a line joining the final mark on the angled line to the corresponding end of the original line.
3. Work back from each mark, using ruler and set square to draw lines parallel to the one made in step 2. Where these cut the original line, they mark equal divisions.

Time-saving preparation

When working out your finished layouts, it's often useful to photocopy headlines, photos and illustrations to various sizes which you can shunt around and juxtapose on your grid. In this way, you can quickly and easily judge the effect without the time-consuming job of tracing at various sizes on the visualizer. Headlines can be cut and sliced, line breaks changed instantly and different layouts compared.

❝Photocopy the main elements of your design at varying sizes to try out different ways of laying them out❞

Getting the picture

An invaluable yet inexpensive aid when deciding on how to crop photographs, transparencies and illustrations is pieces of card cut into L-shapes and used in pairs to form rectangles of any size or proportion. Keep a few cut to different sizes in both black and white to use over illustrations and photographic prints. Keep smaller ones by your light box for transparencies.

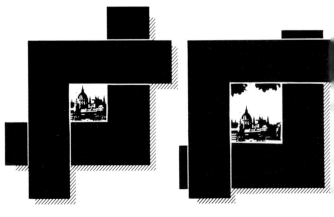

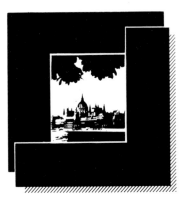

❝Use two L-shaped cards to try out different ways of framing your image when deciding how to crop a picture❞

When selecting from transparencies in strip form, use a window mount cut out of black card. This enables you quickly to isolate one image from the rest of the strip and cuts out the glare from the light box. Make up window mounts for each of the different sizes of transparencies which you commonly use.

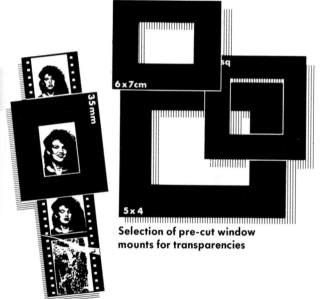

Selection of pre-cut window mounts for transparencies

Sizing pictures

Use this simple method of scaling up or down for photographs, illustrations or transparencies when working on your design layout. Work on an overlay trace with pencil, but be careful not to damage your original print by using too much pressure. This is a particularly good method when you have to have a fixed width or depth, for example when the picture must match column width.

On the overlay trace, draw in outline the shape and size of the image you wish to reproduce. Draw a diagonal line across the area. Place the marked overlay sheet over the picture or artwork. Align the bottom left corner with the corresponding edges of the image area to be reproduced.

To obtain the correct proportions to fit the required picture area, the top right corner of the original image must fall on the diagonal drawn through the overlay outline.It may be necessary to readjust the outer frame of the required image area until the corners are both aligned on the diagonal.

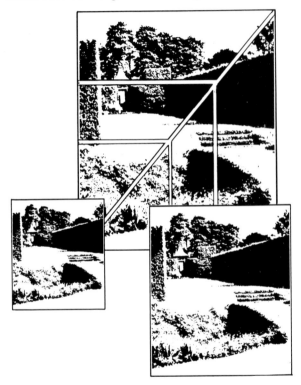

❝Check the diagonal alignment of your image areas when scaling pictures up or down❞

Working in pro

When you are producing many artworks for ads, first use a pencil to draw up on a sheet of tracing paper all the sizes of the artworks with the bottom right corner in common to all. When you have done this draw diagonal lines from bottom right corner to top

left through the various sizes. In this way you will see which artwork sizes, if any, are in proportion to each other and can be taken from the same original, thus saving much time and expense preparing mechanicals for every size. Once you have worked it out, it helps to draw over your pencil lines with a different coloured pen for each series.

For quick reference, be sure to keep this trace on file. Your client may well repeat the same media bookings on a new campaign months later

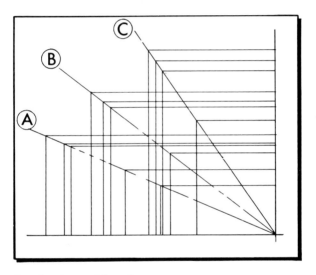

Designing with colour

When designing simple flat colour illustrations, logos or diagrams, you can easily see them in different colourways without redrawing every time. Simply draw up one version, then have laser prints or colour photocopies made, instructing the operator to change the colours as you require. Any or all colours can be changed, and prints produced in as many different versions. Even black and white tone drawings can be converted to colour.

❛❛Take advantage of colour-copying facilities to try different versions of your design colourways❜❜

LINE ARTWORK

Get it right and keep it clean — this section is full of tips for achieving a professional finish to your camera-ready artwork.

Accurate positioning

The calculator comes in handy as much for the
finished artist as for the layout artist. For example,
when centring artwork on line board
The line board is 730mm wide, trim of A4 brochure
spread is 420mm
730 - 420 = 310 ÷ 2 = 155
The margins are 155mm
Repeat the calculations with the upright dimensions
for centring on depth.

Calculating percentages

The calculator is also the quickest way to work out
enlargement and reduction percentages. First take
the measurements of the original in millimetres and
the same for the required reproduction size.
For enlargements, divide the reproduction size by the
actual size
330 ÷ 120 = 2.75
Move the decimal points two places to the right to
get the percentage enlargement - 275 per cent.
For reductions, divide the original size by the
reproduction size
120 ÷ 330 = 0.3636
The percentage reduction is also found by moving
the decimal point two places to the right - 36 per
cent.

Centring copy

Use your dividers for centring copy, often a much
quicker method than measuring with a ruler. You can
use them to measure and adjust side margins.

If you have different elements that need to be centred, draw a light pencil line down the centre of the artwork and positioning one point on the centre line, swing the dividers in a semicircle to measure either side until equal.

Repeat layouts

When your work involves repeating a layout, to avoid wasting time drawing up each one individually, mark the necessary lines on your drawing board. Position the layout on the board and secure it with tape. Then extend all the lines, using a T-square and set square (triangle), onto the surface of the drawing board. Before removing the master layout, mark the corners so that you can position the next sheet accurately.

For subsequent layouts, simply project the lines on your drawing back onto the surface you are using for the artwork.

❝Mark the lines of a repeat layout on your drawing board as a guide for the artwork❞

Lifting adhesive tape

When you have used tape to secure artwork to the drawing board, always lift it from the artwork end and pull it outwards. If you pull back tape from the edge of the paper or board inwards, it is more likely to take up the top layer or tear the fibres, causing damage to the surface.

Using a technical pen
If the inkflow needs some encouragement
when you haven't used the pen recently, first shake
the pen gently backward and forward a few times
and keep testing the flow. Try stroking the nib across
a damp cloth or wetted fingertip to 'draw' the ink.
Before starting to ink your artwork, test the
pen on a piece of scrap board to check the ink flow.
Always hold the pen vertically for an even
flow of ink and constant line quality.

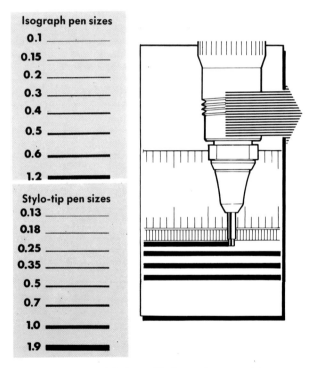

Isograph pen sizes

0.1
0.15
0.2
0.3
0.4
0.5
0.6
1.2

Stylo-tip pen sizes

0.13
0.18
0.25
0.35
0.5
0.7
1.0
1.9

'Touch down' blobs of ink can be a problem.
These are caused by a build-up of ink in the tubular
pen nib. Again, the problem is solved by a quick
wipe on a damp tissue (or finger) before starting to
ink each line.
When retouching damaged lines, use a finer
nib than your original one, to allow for any slight
hand-tremble or other inaccuracy.

If you store pens in a humidifier, you may find your line starts out grey or weak. A few preliminary test strokes encourage a rich, black line.

Keep the cap securely on the pen when it is not in use, keep it clean and regularly carry out a thorough internal cleaning as directed in the manufacturer's instruction sheet.

The point of a technical pen may get slightly worn down in use, so it helps to keep the nib the same way up each time you use it, otherwise any irregularity in the point may cause a ragged line. Mark the 'front' of the plastic nib casing with a small notch so you can always run the pen in the same direction.

❝Retouch damaged ink lines with a finer pen than the original to allow for slight inaccuracies❞

Preventing a bleed

When using French curves or circle or ellipse guides with a technical pen or ruling pen, place a thin strip of card under the guide. This raises it slightly from the surface of your board, paper or film, thus preventing ink from bleeding underneath or smudging against the edge of the guide.

With straight edges - a ruler or set square - you can put a few layers of masking tape on the underside or, if the item has a bevelled edge, turn it over with the bevel downwards.

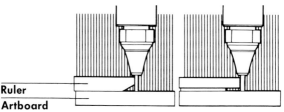

Ruler
Artboard

An alternative to using tapes or card strips is simply to place a sheet of thick paper under your ruler or template. You have the added advantage of being able to rest your hand on the paper without damaging the artwork, and it protects the artwork while you are preparing your brush or pen.

"Raise your template from the artwork surface when inking to prevent a bleed under the edge"

Ink-line correction

When preparing artwork on fine line board, keep a scalpel fitted with a rounded blade rather than the standard straight-edged pointed blade. You will find the rounded type excellent for removing wrongly drawn ink lines, such as keylines and borders. The round blade removes the inked line with much less damage to the board surface, thus enabling the new, correct line to be drawn cleanly, whereas the pointed blade often causes uneven scratching which makes it difficult to redraw a smooth ink line.

The three most common blade shapes

Ink lines can be accurately thinned down by scratching along the edge of a steel rule.

Inking rounded corners

When you have to draw up a border with rounded corners, instant or dry-transfer corners are not always suitable for your job and you may need to hand-draw, especially if you have a multi-line border. One rule to keep in mind is that you should ink the corners before the straight lines.
1. Draw up the border in pencil line, with squared corners.

2. Set a compass to the radius corresponding to the corner curve (based on a quarter-circle). Position the compass point on the corner of the border and mark the radius length on the border lines on each side.
3. The centre point for the corner radius is found by drawing lines at right angles to the border edges from the radius marks to find the point of intersection.
4. Attach a technical pen to the compass and ink the radius line by placing the compass point on the inner corner of the drawn square, swinging the compass between the two marks on the border edges.
5. Repeat for the other three corners of the border. Then using a technical pen with the same line weight as that used for the corner curves, draw in the straight lines connecting the corners.
6. Erase all pencil lines. If the joins between corners and straight lines are not clean and precise, retouch as necessary with white gouache.

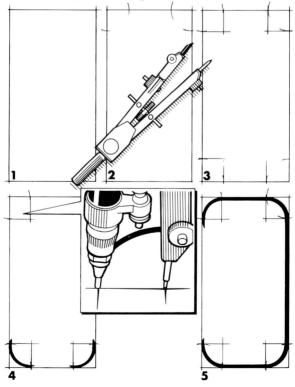

If your border consists of more than one rule, repeat the procedure for the second set of corners. Do not attempt to draw both radii for a single corner at the same time, as this means changing your compass setting. Always complete all four corners for one border rule before adjusting your compass to the new setting.

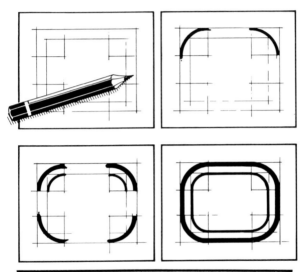

❝Ink the rounded corners of a border before you ink the straight lines❞

The corner curve paste-up technique

This technique produces the same end result as drawing up curved corners, but it can save a lot of time, particularly when producing complicated corner effects. The paste-up may look a little messy, but that is easily solved by taking a PMT and retouching.

1. On your line board, draw a squared border in ink using a technical or ruling pen to achieve the required line weight.

2. On a separate sheet of line paper, draw in pencil the vertical and horizontal axes of a circle, extending them beyond the required diameter (this diameter being twice the radius of the corner curve on your border).

3. Attach a technical pen to a compass and draw an inked circle to the required diameter.

4. Cut accurately along the axis lines with a sharp scalpel blade, but do not cut right across the paper on each side.

5. Cut a square of paper for each segment of the circle, with the axis lines forming two sides of the square. Make this accurate, to avoid optical illusions.

6. Position one of these squares on one corner of the squared up border, aligning the ends of the curve with the border rules. Repeat for all corners.

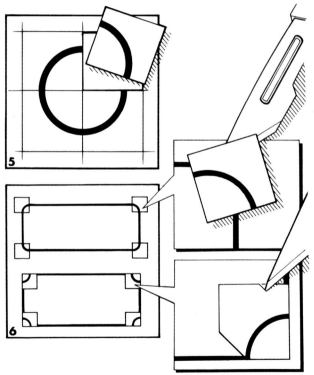

By fixing each segment of the circle to the diagonally opposite corner of the border, you can produce a border with concave corner curves. This method can be used to experiment with different effects, but is not suitable for multiple-line or reversed out solid corners.

Point of accuracy
Use an emery board to keep a clean sharp point on your compass lead, ready for use. Angle the lead to match the length of the compass point.

Troubleshooting
When applying dry-transfer lettering or tints, if the odd character or area of dots goes down wrong, it can be removed by lightly touching with adhesive tape. Be careful not to rub down the tape, or the board surface may be damaged.

If you have put down a word in the wrong place when using dry-transfer lettering, you may be able to pick up the whole thing on a strip of low-tack adhesive tape (you need the invisible kind - transparent and matt-surfaced). Reposition it simply by rubbing down the tape strip in the correct place on the layout. The tape accepts ink if you need to touch up the characters with a technical pen.

For quick touch-ups on camera-ready artwork, keep to hand a technical pen filled with opaque white ink.

If you have a build-up of rubber cement on your artwork, use a clean wad of cotton wool to soak up the bulk before rubbing off the rest.

You sometimes find a spot of ink on acetate or board that has not completely dried, or perhaps a dab of excess adhesive you cannot remove when mounting visuals. In either case, a light dusting of talcum powder applied with a cotton ball will do the trick. It dries off the ink or adhesive, removing any tackiness.

❝To lift a dry-transfer character, touch it lightly with adhesive tape❞

Broken lines

Reply coupons are an example of artwork that requires use of broken lines. Dry-transfer lines are the easiest answer: however, not all clients will accept them, they do scuff and damage easily. The dry-transfer product may not match your design in the width of the rule or spacing of the gaps. Many studios insist on having broken lines inked, and the following is the standard method.

1. Draw double lines with a technical pen to the required width and ink in with a brush.
2. Lightly pencil in the gaps for the broken line, using set square (triangle) and ruler for consistency.
3. Paint over the inked line with white gouache to create the gaps.

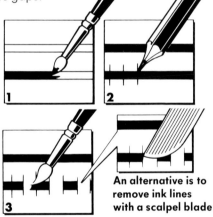

An alternative is to remove ink lines with a scalpel blade

Preparing a surface for line work

Drafting film or line board sometimes has areas which resist ink. You can avoid problems by dressing the surface before you start work, either by shaving lightly with a razor blade or by working over the surface with a hard eraser. This has the effect of giving the surface a slight 'tooth ' which improves the line quality; it is cleaner and more dense, the ink adhering evenly to the surface.

❝Dress the surface of line board before inking, to produce a better line quality❞

Rubber stamp effect

Special offers, flashes etc. on artworks sometimes call for an effect simulating an image printed with a rubber stamp. This characteristically has a slightly broken effect which can be recreated by the following method.

1. Draw the basic border artwork to your chosen shape.
2. Paste in your repro, centred on the border.
3. Pick up some white gouache on a sponge or cotton wool ball. Lightly dab out some of the paint until it is tacky or almost dry.
4. Dab the paint sparingly over the whole image, to give the broken 'rubber stamp ' effect. If you have any fine line copy, be careful not to break it up so much that it becomes illegible.

Smooth finish

Sometimes air bubbles appear in pasted-down repro or PMTs. To solve the problem, prick the centre of each bubble with a pin or scalpel point to let the air out, then smooth down the surface around the pinhole. If the air bubble is large, you may need to make a fine slit which allows you to flatten the bubbled surface evenly.

Try this technique if you have difficulty in getting a large photograph to lie flat without any air bubbles when mounting it on a board. First, soak the photograph in water, wipe off the surplus moisture, then apply rubber cement to the back of the photo and to the board and stick the picture down. As it dries, it will stretch perfectly flat and adhere firmly to the board.

PMT economy

If you want two PMT copies of a small piece of copy or, say, a headline word, a quick and simple way to make two prints in one is to fold your negative paper in two before placing on the vacuum bed and exposing: turn over and expose again, then unfold and process as usual with one whole sheet of positive paper.

Alternatively, instead of folding, cover half of the negative paper with a sheet of red opaque film - or black card will do. Expose and turn, end for end, and expose again.

When you need many small prints of one image - a logo, for example - take a sheet of black paper or opaque film and cut a simple rectangular mask to fit around your image area on the vacuum bed so that only the logo will be exposed. Lay the negative paper over the masked area, starting at one corner of the sheet, expose, then move the paper across by just over the length of your image area, and expose again. Progress in rows to fill your sheet. Then process the negative with one sheet of positive paper and you have a whole sheet of logos in one print, saving much time and PMT paper.

❛❛Save PMT paper by making multiple exposures of small images to print on one sheet❜❜

Altering PMTs

To make corrections, change or clean up the image on a PMT, you can use a two-pen system, such as the Silver Genie, specially made for this kind of work. This is by far the quickest and cleanest way to alter a PMT, for example, to remove marks showing where text has been stripped in, or to delete a background, leaving a cutout image.

A fine-tipped pen is used to remove parts of the image, applied to the appropriate area until the marks disappear. Then the broad-tipped fixing pen is applied to the same area. After a few seconds, simply wipe over the corrected area with a tissue to remove any excess fixing solution, and the altered PMT is ready for use.

I find these pens especially useful for simple line illustrations or outline lettering that needs colour-separating. For instance, with 3-colour illustration, take three PMTs of your complete line illustration with registration marks included, then assign one PMT to each colour and simply delete all lines and marks except those which will print in that colour. This is a very quick and accurate colour separation and registration method.

A type curve
If you have to lay type on a tight curve or circle, first draw two parallel lines with a compass to the desired curvature or diameter and spaced to match the cap height of your type. Cut between each character of the type with your scalpel, but without cutting through the baseline.
Apply the adhesive you usually use for paste up, then place the type over the drawn lines and fan it out to sit between the lines following the curve. You may need to cut through and adjust slightly, especially if you have closely spaced type.

The stages in setting out curved type

Typographic reference

When your typesetting comes in, take a photocopy before cutting and pasting the repro. Keep the copy with your job sheet and should you need amendments, you can use this to mark them up (or take another copy). The typesetters' job reference number is there for easy access: they will need it to find your computer disc file or to do a costing should you need one before the invoice comes in.

"Always photocopy typesetting before you cut and paste it, so you have a complete reference if amendments are needed"

Adding accents or symbols

If your copy includes foreign accents or small symbols which cannot be easily reproduced in the typesetting, get rows of the symbols set individually on clear self-adhesive film rather than on opaque bromide paper, with an allowance for cutting space between them. These can be easily applied to the main body of the text repro as required, saving time and expense on the typesetting.

A disposable work surface

When you are pasting up, use an old telephone directory or mail-order catalogue as a temporary work surface. After applying adhesive, tear off the top page so that you continually have a fresh, clean surface to work on.

"Use an old telephone directory as a base for pasting up and tear off the pages to give a clean surface as required"

Rubber cement eraser

The easiest way to rub away traces of recently applied rubber cement is to use a ball of dried adhesive. When your tin of rubber cement is almost empty, rather than scraping out the remains from the bottom and sides of the can, just leave it out on a shelf with the lid off and allow the residue of cement to dry. Remove it by easing it out with your fingers and roll it into a ball to make a fresh, clean adhesive eraser.

Quick correction

Use a scalpel point to carefully pierce tiny pieces of type for copy amendments and hold them up on the scalpel while spraying them with adhesive. Be extra careful not to stick the point into the repro where it may damage a character.

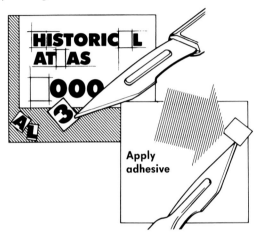

Apply
adhesive

Picking up and spraying small bits of copy with adhesive using the tip of a scalpel.

Either keep a special scalpel for this purpose or constantly clean the blade with a solvent to remove the adhesive. Otherwise it gets very messy and will be no use as a cutting blade.

Special effects in lettering design

Using computers and special lenses, typesetters can create virtually any special effect in lettering that you require, but there is a simple do-it-yourself technique you may find helpful which uses the PMT camera. Place your lettering on a sheet of card and angle it, propped against a heavy solid object on the base or bed of your camera. This gives an angled type effect. For a curved effect, wrap the lettering around a can or cardboard cylinder and take a line print. Stop the PMT lens down the maximum amount for greatest depth of field and take a visual check on the focusing.

Line correction

If you find when pasting up your artwork that you have extensive amendments which entail cutting and moving many lines, changing line breaks etc., and no time for resetting, instead of pasting the repro onto your artwork, first paste it to a small piece of mount board taped to your drawing board at the side of your artwork. Then using your parallel motion, slide through each line, lift and place on the artwork as necessary, working down the column or page. Your repro is neatly cut with parallel lines and already pasted, much better than trying to gum tiny strips and individual words.

When complete you may decide to PMT the 'new layout' and paste that to your final artwork.

Reversed copy

If you are preparing artwork that has large areas of reversed out copy, either from black or a colour, you will find the following method simpler, quicker and less messy than painting the large areas with black ink.

1. Draw up the area with a heavy keyline.
2. Lay down red opaque film over the artwork.
3. Carefully trim (you can see through the film) to the keyline with a sharp scalpel, with bleed as necessary, and peel off the excess.
4. Paste up your reversed copy. If you need to cut out areas for photographs, illustrations etc., you will find that if you use a new scalpel blade, the red opaque leaves a good clean, sharp edge even without a drawn keyline.

Eliminating white on a negative paste-up

If you are applying negative photocopies or PMTs to a black background, the thickness of the paper can cause white lines to show around the pasted-up sections.

To avoid this, touch up the edges with a waterproof black ink after trimming to size and before pasting down the negative print.

Mapping

When preparing street maps, such as 'where to find us' illustrations on ads or company brochures, an easy way to produce your artwork is to first take a

photocopy from the A-Z guide or an appropriate
street map of the town including the particular area
you need to cover. You may have to enlarge this to a
good working size.

Place the map on a light box and cover it with a
good quality line paper. Decide which roads you
need to show: you will probably simplify the original,
showing only the main and appropriate sub roads.
Lay ruling tapes over these roads. You can use
different widths to denote importance.

When all the required tapes are laid, outline the
edges of the tape with a pen. When this is done,
remove the tape leaving a clean, even image of the
road widths. Add typesetting for road names and the
company location etc., and finish off by touching up
the image with white paint where necessary. Take a
PMT to the required size.

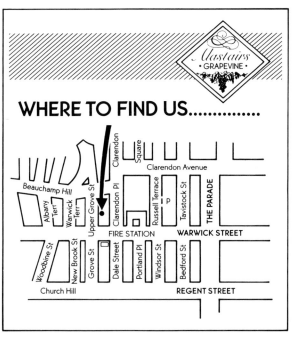

**"When constructing a street map, use
ruling tapes to lay out the road scheme"**

chapter five

ILLUSTRATION

Impressive colour artwork
usually involves more
labour than inspiration.
These hints will help you to
achieve economy of
method without sacrificing
the effect.

ILLUSTRATION **53**

Drawing up an illustration

When transferring a final trace (do use tracing paper not layout paper) of your illustration onto line board or stretched paper, instead of working with the previously much-used red transfer paper or, worse, the sometimes-used typists' carbon paper, try this simple method of using a thick stick of graphite. Roughly scribble over the lines of your illustration on the back of your trace, then gently rub over with a soft tissue or cotton wool, spreading the graphite and at the same time removing the surplus. Then place your tracing over the board, tape it down and draw lightly over the lines with a hard pencil. You will find you have a clean, sharp, fine line on the board with no greasy residue or unnecessary marks to clean up.

If you use a tracing or transfer method that means going over all the lines twice, you usually get some inaccuracy in the final image. In some cases you can try the quicker method of tracing off from the original in reverse - by placing it upside down on a light box and making a pencil trace using a softer-grade pencil than usual. Then place the traced image graphite-side-down on your paper or board and rub over the surface to 'push down' the graphite lines.

Detailed accuracy

When tracing from a photograph containing fine detail, use a thin layer of rubber cement so that the tracing paper adheres to the surface of the photograph. This tight contact makes the detail show more clearly, and you can easily clean the photograph afterwards by rubbing off the dried rubber cement.

Visibility

When tracing onto a dark background, use white chalk to rub over the back of the trace before going over the lines.

Non-repro blue

If you are preparing a complex drawing for ink-line work, use a non-reproducing blue pencil to make the drawing. You can apply ink over the blue line, but construction lines in the drawing do not have to be erased as they will not show up in reproduction.

Cleaning up

Where you do need to remove the lines of an original trace from your line board, if they are laid down with graphite or transfer paper, the quickest way to clear them is to lay masking film over the surface and lift it immediately. The 'pencil' lines lift on the film adhesive.

Clean water

When you are painting with water-based paints or dyes, add a few drops of mild detergent to your water jar. This should not affect the way the paint goes on, but it keeps the jar cleaner and makes it easier to rinse out when you change the water.

ILLUSTRATION **55**

Avoiding a puncture

When using a compass for drawing on artwork, especially illustration and airbrush work when you must not puncture the surface with the compass point, position the point on a piece of card taped to the artwork.

Artboard economy

Artboard can be an expensive item, and usually you don't need to present artwork on a rigid surface when it goes for reproduction. You can obtain papers of similar surface quality to artboards, which can be mounted on an inexpensive cardboard to keep them rigid while you work, but you can then lift the flexible top layer when the artwork is complete.

❝Instead of working on artboard, use an equivalent art paper to give the flexible surface needed for current reproduction methods❞

Paint consistency

A tip to bear in mind when using diluted paint in a ruling pen or airbrush is that the colour should be of a milky consistency, neither too thin nor too creamy.

Shaping a brush

To 'trim ' a paintbrush to a fine point, use the flame of a match or lighter rather than a knife or scissors. This is a delicate procedure, but much more effective than cutting the bristles.

Protecting airbrushed colour

Sprayed gouache has a fine matt surface which is easily marked. To give it a slightly glossy, more resilient finish, mix in a little gum arabic when you dilute the paint.

Alternatively, spray a thin coat of gum arabic over the whole completed image.

❝Mix a little gum arabic with gouache when airbrushing to help protect the sprayed surface❞

Guidelines for mask cutting

To get an accurate image of an original pencil drawing on self-adhesive masking film, peel the backing paper from the film and smooth the film down over the drawing. When you lift it, the graphite lines will be picked up by the adhesive, and you can simply transfer the masking film to your artboard.

ILLUSTRATION **57**

Some photocopiers will allow you to take a copy of a keyline drawing directly onto masking film. **Alternatively, a useful base** for colour work, especially airbrushing, is a grey-line (underexposed) PMT of the keyline artwork printed on matt-surfaced paper.

❝Keep your airbrush work clean by applying the keyline drawing directly to the masking film❞

Mask edges
It is sometimes difficult to see the line of a masked area when you are using self-adhesive masking film which adheres tightly to the surface. To avoid this, after laying the masking film, lightly airbrush a fine layer of colour over the film before cutting. This makes it easier to see the edge of the mask against the illustration board when you have cut the shapes for spraying.

Cutting film cleanly
You may find it easier to cut and lift masking film if you first wet the blade of your scalpel. The moisture softens the emulsion layer of the film, making it easier to cut without damage to the ground layer. Wetting the surface of the film has the same effect. Obviously you cannot risk this method if the mask covers previously painted surfaces which may bleed or smudge if the moisture comes into contact with the colour.

Masked patterns

Self-adhesive dots or stars can be used as masks to make repeat patterns for airbrush or marker work. You can lift them afterwards by touching lightly with low-tack tape.

Torn paper masking

Masks made from torn paper are favoured in airbrushing for creating soft, irregular edge qualities, and the same technique can also be used in marker and coloured pencil work. For a hard-edged effect, use paper with a cut edge, straight or curved as required.

ILLUSTRATION **59**

Securing loose paper masks

A simple way to anchor a loose paper mask is to keep handy a sheet of metal which can be slipped underneath the artwork, and magnetic weights which can be placed on the paper mask to hold it down. This keeps the mask securely in place without any marks on the artwork.

Clean colour

This is a tip for getting a clean image for charts, technical illustrations and diagrams that basically consist of line drawings, plus copy, and the application of either flat colour or colour washes (brushed or airbrushed).

Do your basic illustration in line only, paste up all the repro, then make a PMT negative. Print this onto matt paper and after thorough washing you can apply your colour to the print, using masking if necessary for airbrushing. This surface is ideal for colour washes, not repelling the ink or dye.

Even colour

When applying ink, dye or gouache, either brush-painted or airbrushed, some surfaces - especially acetates or plastic - will partially reject the paint giving an uneven finish. To prevent this, simply mix a very small amount of washing-up liquid or soap into your paint before applying the colour. This acts as a wetting agent and your paint will 'take ' more easily. **Ox-gall, sold as a watercolour medium,** has the same effect of spreading the colour more smoothly.

Alternatively, a light spray of fixative may make the surface more receptive

❝Add a little washing-up liquid to water-based paint or ink to make it spread more evenly on a resistant surface❞

chapter six

PRESENTATION

Whatever the purpose of
your presentation, make
sure both you and your
work demonstrate the
professional touch.

Keep your own record

A problem that I find frequently occurs with presentation work - especially finished visuals and artwork done for promos, often involving days and nights of intense work - is that in spite of having produced a spread of work you may be very proud of and would dearly love to have in your personal folder, all is lost the moment you deliver to the client. Work done for promos often never goes to the print stage, so you have no chance of asking for samples. Before delivering, try to copy all work on transparencies, or at least get laser prints or colour photocopies. If possible, have a tiny corner of your studio with photospots, a pinboard and a camera on a tripod permanently set up, always ready to get an instant record of those winning visuals.

❝Make a personal record of your presentation work before delivering to the client❞

Take your chances

When delivering work to a client, take along some colour transparencies showing a carefully selected representative sample of your work. When discussing the job in hand, there may be an opportunity to compare design ideas or techniques used in previous work. Showing transparencies not only assists you in explaining your ideas, it provides the client with a broader view of your capabilities.

Versatile mock-ups

If you feel clients are not sure of what they really want, instead of spending time on a detailed mock-up and finding that you have to do it over again if it does not meet with approval, make preliminary mock-ups on acetate allowing each element of the design to be treated separately. Work in colour on the back of each acetate sheet, giving a clean image on the right side. Typography and illustration can be viewed through the acetate, and when showing the presentation you can vary the different elements until the client sees the right combination.

Protecting artwork

Before covering illustrations, especially airbrushed work, gouache or watercolour paintings, or retouched photos, it is best for their extra protection to add an acetate overlay. Clients love to put their sticky fingers on your work, often leaving marks impossible to remove.

Lay the acetate sheet to cover the illustration completely, tape across the top edge with clear or invisible tape, turn the board over, trim flush, then cover as normal. If you are using a window mount, place the acetate under the window.

Covering your artwork

There are good practical reasons for covering artwork - primarily to prevent getting it dirty or damaged, secondly to apply a trace or detail paper overlay on which to write instructions for the printer and thirdly, if you always use the same paper and colour for the outer cover, to establish a recognizable image for your artwork.

1. Cut your cover paper and a detail or tracing paper layer if required, slightly larger than your artwork. Lay the artwork on top face down.

2. Place a strip of double-sided tape across the top edge of the paper, half on the detail paper, half on the cover paper. Make sure this edge corresponds to the top of the artwork.

3. Cut through detail and cover paper at the top edge, at an angle from the top corners of the artwork.

4. Fold the 'flap' down over the back of the artwork, running a scalpel handle or your thumbnail down the edge to make a positive, clean fold. Then remove the backing from the double-side tape and press down firmly.

5. Carefully trim the cover paper flush to the edges of the artwork, using a steel rule.

To finish, apply a label with your own or company name to the front cover flap. For a very professional finishing touch, you can alternatively have an embossing stamp made for identification, rather than using a label.

❝Make covers for your artwork both to protect it and to establish a recognizable identity❞

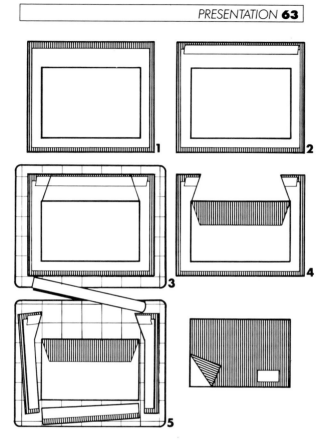

Mounting

Mounts provide additional strength and protection for your artwork. Flush mounting is the method used if the mount itself is not to show; alternatively the artwork can be presented with a border or window mount to give a clean, open finish.

Flush mount

1. Place the artwork on a piece of mounting board and cut around all sides, allowing about ¹/₂ in / 10mm over the final size required. Make trim marks on the right side of the artwork and make small cuts through the edges towards the marks.
2. Turn the artwork over and run double-sided tape along each edge on the wrong side, making sure it just covers the cuts. Remove the backing paper from the double-sided tape.

3. Position the artwork on the board, matching up the edge cuts, and press down so that the tape adheres firmly. Use tracing or detail paper to cover the artwork as you do this, to avoid fingermarks on the surface.
4. Align a metal rule to the trim marks and score the surface along each side.
5. Work around all the edges again to cut through the board. Repeated light cuts make a cleaner finish than heavy pressure to cut right through in one. Clean up the edges of the mount to remove any loose fibres from cutting the board.

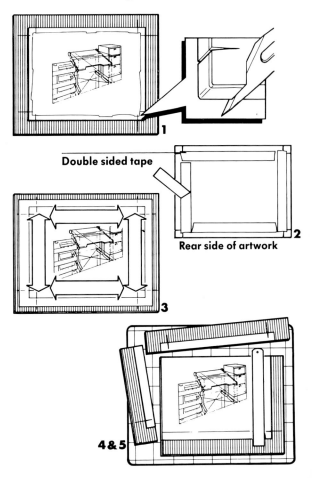

Double sided tape

Rear side of artwork

4 & 5

Border mount

1. As for flush mounting, make the trim marks on the right side of the artwork and make small cuts into the edges.

2. Turn the artwork over and lay double-sided tape along the edges on the wrong side, leaving the backing strips in place.

3. Turn the artwork back to the right side. Trim the edges aligning the cuts with the trim marks. and cut along the trim marks. Discard the trimmed borders. Remove the backing strips from the double-sided tape on the back of the artwork.

4. Place the artwork on a sheet of mount board, allowing a generous margin on all sides. Press down to adhere the double-sided tape.

5. Measure the width required for the border on each side of the artwork. Make small pencil marks as a cutting guide. It is usual to allow a little extra depth on the border along the bottom edge, as this gives a visual balance.

6. Using a steel rule to align the pencil marks, cut off the excess board around the artwork border. Finally, clean up the edges of the mount and the surface of the artwork.

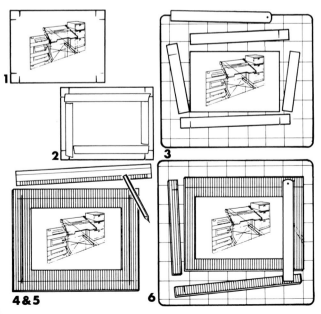

Window mounts

1. To find the widths of the borders for the window mount, position the artwork on the mount board aligned to the bottom left corner. Use a strip of paper to measure off the distance from the righthand edge of the board to the edge of the artwork. Fold the paper in half and you have the measure for each side border.

2. Use this method to obtain the top and bottom borders, but allow a little extra at the bottom for a balanced effect in the mount.

3. Check that the border measurements will allow a slight overlap onto the artwork edges so the window frames the image. Draw up the window area on tracing paper with register marks for the outer edges of the board.

4. Place the tracing paper over the board, tape it in place and cut through both layers. (Make a hole at the centre of the trace to secure the inner area while you cut.)

Alternatively, prick through the corners of the area marked on the trace and cut the board separately between the pin-pricks.

5. Lift out the cut window, position it over the image, and tape the artwork to the back of the mount along the top edge.

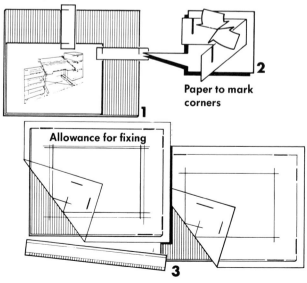

Paper to mark corners

Allowance for fixing

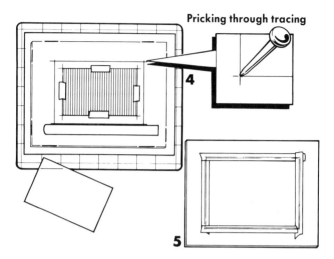

Pricking through tracing

Cutting the window corners You may find it easier to cut accurately into the corners of a window mount if you make your main cut to within two or three millimetres of the corner, then turn the scalpel and ease the blade down to 'guillotine ' the blade into the corner. This way, you are less likely to cut over the corner mark.

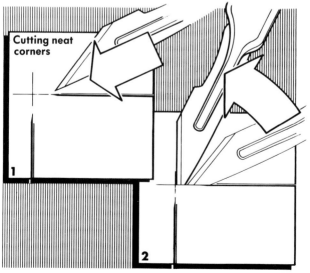

Cutting neat corners

Retouching photographs

When you need to retouch a black and white photograph, you'll find that a grey mixed from pure black and white shows as a bluish tint on the photographic greys. To counteract this, mix in a little Vandyke brown, which produces a warmer grey closer to the photographic tones.

❝Add Vandyke brown to greys for photo-retouching to get the right kind of warm tones❞

Displaying transparencies

When your presentation includes a number of transparencies, it makes a more compact, impressive package if they are mounted together rather than handed out one by one.

1. Assemble the transparencies in sequence and devise a layout that enables them to be viewed clearly as individual images and in their correct relationships as a group, with appropriate borders between the transparencies and on the outer margins.

2. Cut a piece of thin card to a size accommodating twice the size of the layout plus a little extra length. Fold the card in half and check that the layout fits the format, with an allowance for trimming off the fold.

3. Draw up the layout accurately. Place the card on a cutting mat and use a sharp scalpel to cut out the 'window' areas, working through both thicknesses of card.

4. Unfold the card. Cut strips of opaque drafting film to cover the window areas on one half of the card. Secure them with double-sided tape placed over the edges of the strips. Make sure the tapes do not overlap the windows. Position the transparencies glossy side up over the film, accurately aligned to the windows. Attach the edges of the transparencies to the double-sided tape.

5. Cover the other half of the card with a piece of clear film, secured with double-sided tape as before.

6. Re-fold the card and press down evenly so that the double-sided tape secures the two halves together, enclosing the transparencies in between. Trim off the fold.

Keeping transparencies clean
If you have access to an air gun, keep it handy when mounting transparencies behind glass or acetate. A quick blast of clean, dry air blows off dust particles.

Marking out a mount

When you are mounting multiple images together on a sheet of coloured paper, this is a quick, clean way to mark the mount positions. Work out the areas first on tracing paper, then put the trace on a light box and lay the paper over it. Mark the corners of the areas drawn on your trace using tiny pin-pricks through the paper. You can then paste up on the light box using the pin-pricks as your guide, but when you take the mount away from the light, the marks will not show up on the finished presentation.

Displaying a presentation

The normal method for storing and presenting your personal work is to insert artwork or printed samples into acetate sleeves kept in a ring-clasp portfolio. This enables you to update and change your presentation simply by sliding in and out new samples.

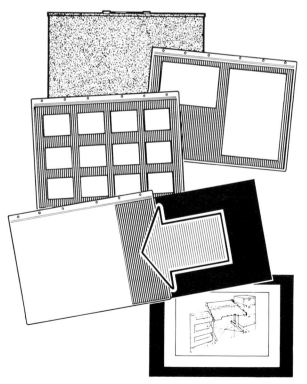

An alternative form of presentation, which I prefer and find more flexible and which clients seem to find impressive, is to use a box folder, (more often used by photographers) containing laminated samples. These box portfolios come in different sizes and look like large briefcases, usually made from light wood and covered with a mock-leather finish, with smart clasps and locks.

Within the box, your work is stored as single sheets, which you laminate to give them permanent protection. This way it is quite safe for clients or interviewers to handle the samples freely and pass them around. The box lid stands upright and has a flap lined with a material which 'accepts' pieces of touch-and-close fastening, which you can buy in the form of small self-adhesive tabs. Stick one side of a tab to each corner on the back of your laminates with the rough side of the fastening outwards. You can then easily pick up each sample and stick it to the box lid as you talk through the presentation.

❝For a smart presentation, make an individual folder to keep together and protect a set of roughs or visuals❞

Making a folder

When you have a complete set of visuals or artworks to be shown as a presentation, it presents a smart appearance if the single job is kept together in a specially-made folder.

1. Measure up the dimensions of the artwork to be kept in the folder. Make a paper template for the folder, folding and fitting the paper around the visuals, allowing for a top flap which is inserted in a slit on the other side of the folder.

2. When you have the right form for the template, place it on a sheet of cardboard and mark out the shape in pencil.

3. Go over the marks using a pencil and ruler to draw out the shape accurately.

4. Cut around the outer edges and score the fold lines. Use a steel rule for cutting.

5. Attach double-sided tape to the edges, fold the card and seal the edges together.

6. Insert the presentation material, fold down and secure the top flap. The purpose of the folder is to give the client a neat package which protects the artwork and keeps it all together. Put your name or company name or logo on the front for identification, and the job title if appropriate.

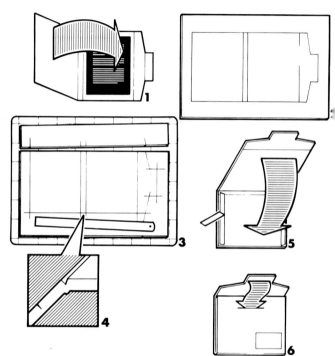

Presenting a set of roughs

A simple, lightweight folder can be quickly made from corrugated plastic boards to keep roughs together for a presentation. This takes little trouble or expense, but it keeps the work together and gives it a professional look. The corrugated plastic is available in black, white and a selection of bright colours, so you can make a choice which gives the presentation an appropriate identity.

1 Cut two equal sheets of the corrugated plastic board; large enough to contain the outer dimensions of the roughs.

2. Using heavy-duty plastic-coated cloth tape, in either a matching or complementary colour, wrap tape around the corners of the boards with the join on the same side each time. This strengthens the corners and gives a smart finish to the folder.

3. Tape the two boards together along one edge, leaving a gap between them to allow for folding the boards together, and to accommodate the amount of work to be inserted. Tape both sides in a continuous run, with the join on the inside, making sure the joins on the corners will also fall on the inside of the folder.

4. Construct a paper pocket to hold the work, approximately one-third the depth of the folder. Place a sheet of matching-coloured cover paper under the board, to the required depth. Attach double-sided tape to the board on the long edge and on the sides to the depth of the pocket.

5. Peel the backing strips from the tape, turn the folder over and place it down on the cover paper. Trim the excess borders of the cover paper with a scalpel, being careful not to cut the board or the taped corners.

6. Slide your presentation into the pocket and close up the folder. Add your label or logo to the front of the folder for identification.

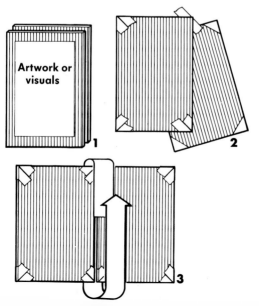

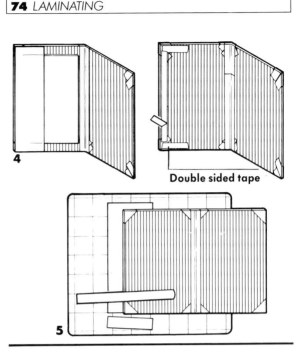

Double sided tape

"Make sure your name or company logo is clearly identifiable on a presentation folder"

Laminating a dummy book jacket

A dummy jacket looks good and is well protected when covered with low-tack self adhesive transparent film. It is also possible to remove the film if you have to make revisions to the design, but it can be tricky to lay the film without getting bubbles or creases.

1. Mount the dummy jacket on coloured cartridge paper and place it on a clean cutting mat. Cut a piece of self-adhesive film, allowing 1in/25mm over the full width of the jacket on each side, 1in/25mm at the top and 1¼ in,/30mm at the bottom.

2. Peel off a thin strip of the backing paper. Attach the adhesive strip of film to the cutting surface at one end of the dummy jacket. Gradually peel away the backing, using a plastic ruler to spread the film flat over the artwork. Work slowly and maintain even pressure with the ruler to avoid raising air bubbles in the film.

3. Where there are raised images on the artwork, cut through them carefully with a scalpel so that you do not get an airlock under the film. If air bubbles appear, prick them with the scalpel and smooth down the film.

4. When the film is cleanly adhered to the artwork, trim the borders and corners, turn over the jacket and fold down the film on the inside edges.

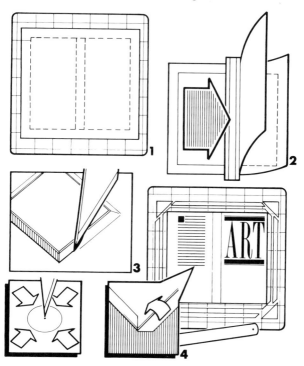

The right finish

If you use clear self-adhesive film to cover and protect a dummy book jacket or package design, remember that you can choose a matt or gloss finish. If you are photographing the work, for example, for a catalogue or pack shot, the matt-surfaced film is a better choice because it won't reflect the photographic lighting. Test it first to make sure the covering doesn't affect the colour values of your artwork.

GLOSSARY
OF TERMS

Acetate A transparent plastic sheet material, available in different thicknesses and matt or gloss finishes, used for artwork overlays, visuals and presentations.

Acrylics Paints made with a binder of synthetic resin which can be mixed and diluted with water but dry to a flexible waterproof finish.

Airbrush A mechanical painting tool which emits a fine spray of paint particles by combining paint and air under pressure. Airbrush work includes very smooth effects of flat or gradated colour.

Annotation Typographic labels or key numbers applied to illustration work.

Artboard A general term for the range of relatively rigid paper sheet products used for artwork and illustration.

Artwork Graphic work including type matter or illustration presented in a finished form suitable for reproduction.

Ascender The part of a lower case letter that rises above the x-height, e.g. the rising stroke of a d.

Axis An imaginary line passing through an object or image which divides it symmetrically or with an approximate balance of elements on either side.

Background The overall area of an image on which the main elements of the image are arranged.

Bar code A pattern of vertical lines used as product identification, often required to be included in the design of packaging, book jackets etc.

Base line A guide line on which the bases of capital letters are aligned.

Bevelled edge An edge cut at an angle to the main surface, usually at 45 degrees.

Binding Any of various methods of securing printed pages in a particular sequence within covers, as in a book.

Bleed 1. Colour which has spread on a surface into an area where it is not required. 2. A printed image extended across the margins of a trimmed page.

Blind embossing An image made by impressing a surface rather than by printing.

Blues, blueprints See Ozalids

Blurb Copy written as a sales device, for example, in an advertisement or on a book jacket.

Body copy/type The main part of the text matter in a design, not including headlines etc.

Bold The description of a typeface in which the letters are thickened and print as heavy black, as compared to light or medium weight in the same typeface.

Book jacket A loose printed paper cover folded around the bound cover of a book.

Border 1. A continuous rule or decorative line framing some element of a design. 2. An area surrounding an image, for example, on a border or window mount.

Box rule Hand-drawn or typeset rules forming a box around, for example, an illustration or block of type.

Brief The instructions for a design job provided by the commissioning client or art director.

Brochure A short publication without binding or hard covers, usually containing information or promotional material.

Bromide Photosensitive paper on which an image or text may be produced, e.g. photography, typesetting.

Bullet A large dot used with type or lettering to give emphasis.

Burnishing The action of rubbing down dry-transfer letters.

Camera-ready artwork Finished artwork ready to be processed for reproduction.

Cap height The vertical measurement from top to bottom of a capital letter.

Caption A line or block of text specifically referring to an illlustration.

Cartridge paper A general-purpose uncoated paper available in various weights and colours.

Cel An acetate overlay.

Centring rule A ruler marked with measurements reading both ways from a zero at the centre of the rule.

Coated paper Any type of paper finished with a mineral coating to improve the texture.

Colour proofs Printed sheets of illustrations and any other colour elements within a design run off for approval or correction by the designer and client.

Colour separation The method of reproducing colour artwork by scanning it to break down the image into four process colours for printing.

Column A vertical section in a design, providing the guidelines for positioning elements such as a block of text running down the page or tabulated copy.

Compass A drawing instrument for describing circles and arcs consisting of two hinged arms, one with a point, the other carrying the drawing tool (pencil or pen).

Condensed The description of a typeface in which the letters are compressed laterally to give an impression of narrowness and height.

Copy Written material for typesetting.

Copyfitting Calculating the size at which copy can be typeset to fit a given space.

Copyright Ownership of the right to copy or reproduce a creative work such as a design or illustration.

Corporate identity A basic design scheme created for a specific company to present a consistent and recognizable identity.

Cover A sheet attached to the back of artwork which flaps over the front to protect the work.

Cropping The process of selecting part of an image for reproduction.

Cutout An image cut out of its background when printed, i.e. presented with a free outline.

Cutting mat A rubber mat printed with a squared grid which can be used as a guide to cutting.

Cyan A shade of blue, one of the four process colours used in printing.

Diagram A drawing that presents information in graphic terms.

Depth of field The area in front of or behind the focal point of a photographic image, within which the focus of the image remains acceptably sharp.

Descender The part of a lower case letter that drops below the base line, e.g. the tail of a g.

Detail paper A thin translucent paper used for roughs and layouts.

Dividers An instrument with two hinged, pointed arms, used for measuring the distance between two points.

Double-sided tape A plastic or paper tape which is adhesive on both sides.

Dot The basic element of which a halftone image is composed.

Dot screen A glass screen cross-ruled with lines to create a grid of transparent small squares. This is used to convert a continuous-tone image into a dot pattern in halftone processing.

Double-page spread Two facing pages of a publication such as a book or brochure.

Drafting film A clear or semi-opaque polyester film which provides a durable and stable surface for line work.

Dry-transfer products A range of printed sheets of transferable letters, rules, symbols, patterns etc. that can be rubbed down on another surface.

Dummy A prototype design representing the finished appearance of, for example, a book or package, produced in three-dimensional form with visualization of the graphic presentation.

Duotone A coloured halftone effect in which dark tones print black and the mid and light tones are overlaid in a colour.

Dupe A copy of a transparency.

Em rule A dash used to punctuate a text, of standard length according to the type size.

En rule A dash approximately half the length of an em rule.

End matter The back pages of a book containing material supplementary to the main text, such as appendices, glossary and index.

Estimate The calculation of a job fee based on the expected amount of work involved.

Expanded type Type which is expanded laterally, giving a broad, solid appearance.

Facsimile transmission A method of transmitting written words or images via telephone lines, usually abbreviated to fax.

Fixative A clear solution supplied in aerosol cans sprayed on the surface of a drawing to seal it and prevent smudging.

Flat colour The effect of a solid colour, however applied, which shows no marks of application or variation in tonal values.

Flat plan A plan showing the pages of a book laid out sequentially with notes on the contents of each page or spread and the distribution of colour.

Flopped The description of a printed image that has been reversed, as if seen in a mirror.

Flow chart Diagrammatic artwork explaining a sequence of events or related processes.

Flush mounting The method of mounting an image without any surround.

Folios The page numbers in a publication.

Format The term used for the overall dimensions and proportions of a design area, for example, a book page.

Four-colour process The method of printing full colour images by separating into four colours - cyan, magenta, yellow, black - which when overprinted reproduce the colour effect.

French curve A plastic drawing template including various curves in different degrees.

Galleys A set of proofs of typeset text matter.

Gouache Water-based paint which dries to an opaque, matt finish.

Gradated colour An area of colour which passes through any degree of tonal variation.

Graph paper Paper marked with a grid of ruled squares.

Grid The basic divisions of a layout within which different elements of the design are arranged. The grid sets the width and depth of type and picture areas, position of headings etc.

Guide prints Copy images included in a paste-up as position guides for colour reproductions.

Gutter A term commonly used to refer to the division running down between the inner margins of facing book pages.

Halftone Simulation of continuous and gradated tones in an image by means of a pattern of dots of varying sizes.

Hand lettering Any process of constructing letterforms by drawing techniques rather than mechanical processes.

Hard copy The printout from a computer, e.g. in computer graphics or word processing.

Headline A line or lines of type designed to draw

attention and stand out from the body copy.
Highlights The areas of lightest tone in an image.
House style The aspects of editorial or design style specified by a particular company for consistent use in their publications.

Illustration 1. An image created by drawing or painting rather than photography. 2. Any graphic or pictorial image accompanying text.
Image 1. The overall visual impression of a picture or design. 2. A particular illustration, design or photograph.
Image area The amount of space allocated to a particular element of a design.
Imposition The arrangement of pages for printing on both sides of a full sheet so that they appear in sequence when the sheet is folded and trimmed.
In-house The term used to describe processes carried out within a company structure, rather than commissioned out to freelance workers or sub-contractors.
Instant lettering Another term for dry-transfer lettering.
Invisible tape Transparent self-adhesive tape with a matt finish. It is almost invisible when rubbed down and can be written over.

Justified The description of typeset material in which the lines of type are aligned at both sides across a specified measure.

Keylines The main outlines in a piece of artwork.

Laminating Applying a transparent surface layer to artwork to give a higher degree of finish and protection. This can be done with self-adhesive film or by a heat-sealing process.
Landscape format Any rectangular format in which width is greater than height.
Laser print An instant copy taken from a colour original by laser scanning.
Latin body copy Printed Latin words used in visuals to simulate the type areas in a design but not intended to be read.
Layout The overall plan of a design indicating the positions of text and image areas.

Layout paper Lightweight, translucent paper with a smooth finish, used for layouts and roughs.

Letterhead A heading on an item of stationery, usually displaying name or company name, address, telephone and fax numbers etc.

Light box A box with a light source inside and translucent screen over the upper surface, used for viewing transparencies etc.

Line board/paper Paper or artboard with a smooth coated finish, used for artwork and ink line drawing.

Line weight The relative thickness of typeset rules or lines drawn with a technical pen.

Line work 1. All of the black elements in a design, including type as well as rules, diagrams etc. 2. Illustrations drawn in ink line only.

Logo A design consisting of letters or words linked as a single unit, used as a company identity or trademark.

Loose mask A mask used in airbrushing, or other artwork preparation, that does not adhere to the surface.

Lower case The small letters of a typeface, as opposed to upper case or capital letters.

Low-tack adhesive An adhesive that does not form a permanent bond, but will allow items to be lifted or repositioned without damage to the underlying surface.

Magenta The shade of red used in four-colour processing.

Markers Drawing pens with wedge-shaped or pointed fibrous tips fed by a flow of ink from an internal reservoir. There is a wide range of colours and markers are commonly used for colour visuals and presentation work.

Mark-up Copy marked with the designer's instructions to the typesetter.

Mask Any material used to block out particular areas of an image, e.g. to contain colour areas while airbrushing.

Masking film A transparent film with low-tack adhesive on one side which adheres tightly to the surface of paper or board but lifts cleanly. This is widely used for airbrush work, but also has a range of design applications.

Masking tape Low-tack adhesive paper tape, with a wide range of studio applications.
Matt (mat) finish A non-reflective surface finish.
Mechanical An alternative term for camera-ready artwork.
Medium Any of the various materials used for painting and drawing, e.g. paint, ink, dye, pencil, marker.
Mock-up Two- or three-dimensional visualization of the design for a particular object giving an impression of the size, shape and graphic styling.
Monochrome The description of an image in one colour only, though it may contain tonal variations of that colour.
Mount board A heavy board, usually of compressed paper layers, which forms a non-flexible support for artwork, photographs etc.
Mounting Any of various methods of reinforcing artwork by giving it a protective backing or surround.

Negative A reversed-tone image, in photographic processes used to obtain a positive print.

Original The copy or artwork to be used for reproduction in a printing process.
Origination The processing of an image for printing.
Overlay 1. A translucent sheet placed over artwork on which instructions to the printer or corrections can be written. 2. A transparent sheet carrying the images in a piece of artwork to be printed in a particular colour, to be registered either into a black keyline base or as part of a multi-colour image (requiring more than one overlay).
Ozalids Page proof copies printed in blue tones and assembled in the correct running order.

Page make-up The assembly of type matter into the correct layout as it should appear on the page.
Page proofs Printed copies of the page make-up for approval or amendment by the designer or client. Sometimes page and colour proofs are combined so the job can be checked in completed form before printing.
Pagination The sequence of page numbering in a brochure or book.

Parallel motion The system on a freestanding designer's drawing board that regulates the movement of a straight-edge across the board for accurate measuring and ruling.

Pastel A drawing medium consisting of pigment compressed into stick form.

Paste-up A layout showing all elements of the design in their correct positions, either as a guide for page make-up or in finished form as camera-ready artwork.

Percentage enlargement/reduction Calculation of the size at which an image should appear in reproduction, expressed as a percentage of the original size.

Photosetting The method of typesetting in which the type matter is produced photographically on film or bromide paper. This has now replaced older methods of printing from solid type.

Pica A standard unit of type measurement.

Portfolio A carboard, plastic or leather case or folder used for storing and transporting artwork.

PMT Abbreviation for photomechanical transfer, referring to a print produced on a studio process camera that makes copy images to a finish suitable for camera-ready artwork. The range of possible processes includes line and halftone prints, reversed images and colour prints.

Point size The specification of type size based on a standard unit of measurement.

Portrait format Any rectangular format in which height is greater than width.

Prelims The first pages of a book, before the main body of the text, containing the title page, contents, preface etc.

Presentation visual A visual presented to a high degree of finish that gives the client a clear impression of the layout and design style proposed for a particular job.

Process colours Black, yellow, cyan (blue) and magenta (red), the four colours used for printing in full-colour reproduction.

Protractor A drawing guide marked in degrees used to measure angles and divide circles.

Ranged left/right Instruction to typeset lines of copy with vertical alignment at left or right.

Registration marks Marks shown on overlays, text or colour films etc., which are matched up in order to superimpose the various elements of a printed image accurately.

Repro A term generally used to refer to copy typeset on bromide paper, as used for camera-ready artwork.

Retouching Any of various methods of altering or improving an image, e.g. artwork or photography.

Reversed out An image which appears white on a black or coloured background. This can be converted in print processing from black on white artwork.

Rough An initial sketch drawn up by a designer or illustrator to give the client an idea of the look of the proposed artwork.

Rubber cement An adhesive consisting of a liquid rubber solution which dries to a pliable rubbery skin.

Rubdown A dry-transfer design custom-made from the designer's own artwork.

Rules Lines of varying weight, hand-drawn or typeset, used in a design in conjunction with type or illustrations.

Ruling pen A drawing instrument with two adjustable blades which form a reservoir for ink or liquid paint. The blades can be preset to give a particular line width.

Scaling up/down Any of various methods for calculating how to alter the size of an image.

Scalpel A metal-handled knife which can be fitted with extremely fine, sharp disposable blades.

Scatter proofs Colour proofs in which the printed images are not in position or order relating to their appearance on a given layout, e.g. not in the sequence of book pages.

Section A printed sheet which is folded to make four or more book pages.

Set square A plastic triangle with a set of given angles, used for ruling and measuring. In an adjustable set square the sides are movable on a pivot so that the angles can be altered.

Sizing The process of drawing up image areas on a layout and marking instructions for the picture sizes on overlays attached to the originals.

Slide A transparency inside a cardboard or plastic mount.

Spray adhesive Low-tack adhesive sold in aerosol cans.

Spread See Double-page spread

Spraygun A painting tool which emits a spray of paint particles, a larger and less precise version of the airbrush.

Straight edge A heavyweight metal or plastic rule with long, straight edges, used for ruling and cutting.

Stripping in 1. Assembling a composite image from two or more individual images. 2. Inserting type corrections, e.g. a corrected word or line, on a paste-up.

Sub-head A minor headline appearing within a column of text to break up the body copy.

Swatch A collection of standardized colour samples which enable the designer to match inks, markers, papers etc. and from which a printer can mix up ink to match a specified colour.

Tabulation The arrangement of a set of figures or words in parallel columns.

Tear sheet An image or layout torn from, for example, a magazine, used as reference for design work.

Technical pen A drawing pen with a fine tubular nib fed from an internal ink reservoir. Nib units are available in range of standard sizes.

Template A drawing aid consisting of a sheet material, usually plastic, cut with particular shapes, symbols, curves etc.

Tint A colour area formed by printing one or more process colours at full strength or reduced tone: a 10 per cent cyan tint, for example, is a pale blue.

Thumbnails Quick scribbles and sketches used to work out design ideas.

Tones The range of light and dark shades which are variations of a single colour, comparable to a monochrome range from white through greys to black.

Tracing Any of various methods of transferring an image from one surface to another using an intermediary stage worked on a translucent sheet of paper.

Transfer paper A paper sheet with a colour coating on one side, used with tracing paper to transfer an image from one surface to another.

Transparency A positive photographic image on transparent film.

Triangle See Set square.

Trim marks Marks on a layout or artwork indicating where the printed sheet should be trimmed in relation to the image area.

T-square A drawing aid consisting of a straight edge with a right-angled cross bar at one end, used for drawing parallel lines by aligning the cross bar to a vertical edge of the drawing board.

Twice up Artwork completed at twice the size it will be reproduced.

Type Printed characters, i.e. letters, figures or symbols.

Type depth scale A ruler for measuring the number of lines of type in a column, marked at various point sizes.

Typeface Any of the various styles of letterforms that can be typeset.

Typesetting Any of various methods of printing type mechanically. Computerized photosetting is now the common method.

Typography 1. The general craft of designing and producing typeset material. 2. The typeset product.

Unjustified The description of typeset material in which lines of type are aligned at one side only.

Upper case Capital letters in a typeface, as opposed to the small or lower case letters.

View pack A clear plastic file sheet with pockets used for storing and viewing transparencies.

Vignette An area of gradated tone.

Visual A realization of the proposed appearance of a design.

Visualize To develop an idea graphically, producing sketches, rough layouts, prototype designs etc.

Visualizer Studio machine for projecting an enlarged or reduced image from a graphic source, which is thrown onto a glass screen and can be traced off.

Wash Transparent diluted colour, such as watercolour or ink.

Watercolour Water-based paint which has a transparent quality when dry.

Weight The degree of lightness or boldness of a typeface.

Widow A single word or very short line at the end of a paragraph in typeset copy.

Window mounting A method of mounting artwork by cutting out the centre of the mount so that it forms a frame surrounding the image.

X-height The height of lower case letters without ascenders or descenders.

COMMON PAPER SIZES

	millimeters	inches
A0	841 × 1189	33 1/8 × 46 3/4
A1	594 × 841	23 3/8 × 33 1/8
A2	420 × 594	16 1/2 × 23 3/8
A3	297 × 420	11 3/4 × 16 1/2
A4	210 × 297	8 1/4 × 11 3/4
A5	148 × 210	5 7/8 × 8 1/4
A6	105 × 148	4 1/8 × 5 7/8
A6	74 × 105	2 7/8 × 4 1/8

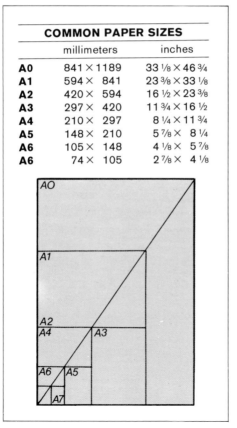

ACKNOWLEDGEMENTS

Series editor: Judy Martin
Design and art direction: Nigel Osborne
Design assistant: Peter Serjeant
Artwork: Nigel Osborne, Peter Owen, Geoff Stear,
Peter Serjeant, Gill Richardson

Outline Press would like to acknowledge the contribution of
the late Bob Chapman in developing the concept for this
book. The range of his experience, expressed in many useful
ideas on studio practice, was of special value in the early
stages of the project.